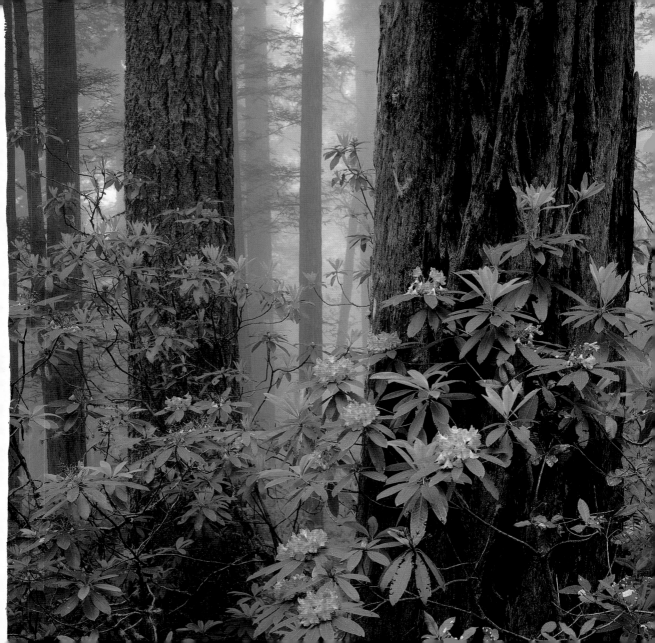

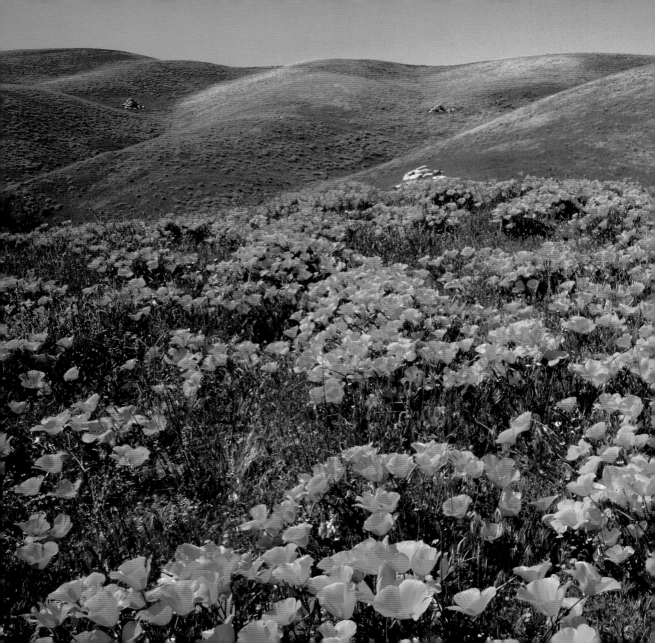

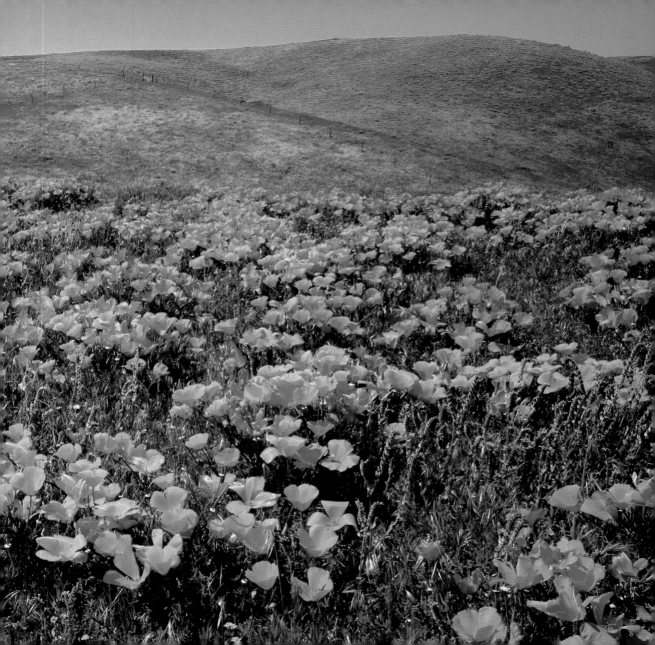

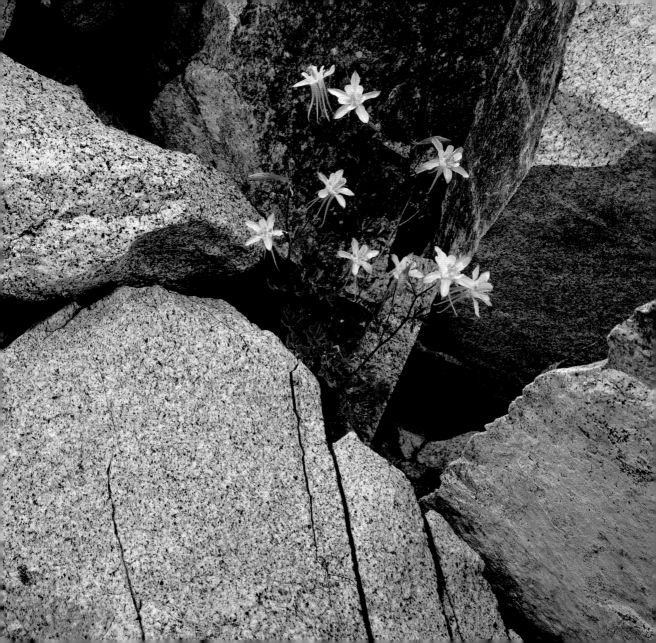

P. N. Tury
Saus Club
Vacaville, 7-28-96

CALIFORNIA WILDFLOWERS

Photography by Carr Clifton
With Selected Prose & Poetry

California Littlebooks

Westcliffe Publishers, Inc., Englewood, Colorado

First frontispiece: Rhododendron, Redwood National Park
Second frontispiece: California poppies, near Antelope Valley
Third frontispiece: Coville's columbine, John Muir Wilderness
Opposite: Paintbrush and sage, Ansel Adams Wilderness

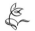

International Standard Book Number: 1-56579-134-7
Library of Congress Catalog Number: 95-62434
Copyright Carr Clifton, 1996. All rights reserved.
Published by Westcliffe Publishers, Inc.
2650 South Zuni Street, Englewood, Colorado 80110
Publisher, John Fielder; Editor, Suzanne Venino; Designer, Amy Duenkel
Printed in Hong Kong by Palace Press

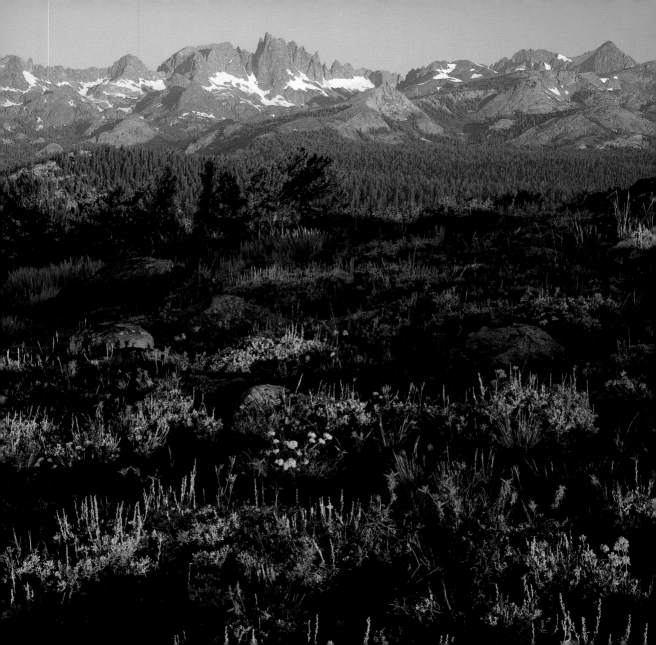

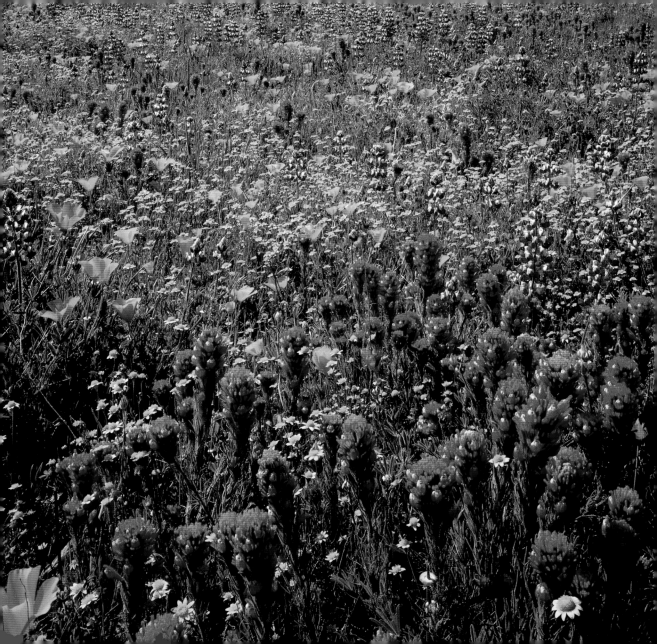

The Bee-Pastures

When California was wild, it was one sweet bee-garden throughout its entire length, north and south, and all the way across from the snowy Sierra to the ocean.

Wherever a bee might fly within the bounds of this virgin wilderness — through the redwood forests, along the banks of the rivers, along the bluffs and headlands fronting the sea, over valley and plain, park and grove, and deep, leafy glen, or far up the piny slopes of the mountains — throughout every belt and section of climate up to the timber line, bee-flowers bloomed in lavish abundance. Here they grew more or less apart in special sheets and patches of no great size, there in broad, flowing folds hundreds of miles in length — zones of polleny forest, zones of flowery chaparral, stream-tangles of rubus and wild rose, sheets of golden composite, beds of violets, beds of mint, beds of bryanthus and clover, and so on, certain species blooming somewhere all the year round....

The Great Central Plain of California, during the months of March, April, and May, was one smooth continuous bed of honey-bloom, so marvelously rich that, in walking from one end of it to the other, a distance of more than 400 miles, your foot would press about a hundred flowers at every step. Mints, gilias, nemophilas, castilleias, and innumerable composites were so crowded together that, had ninety-nine percent of them been taken away, the plain would still have seemed to any but Californians extravagantly flowery. The radiant, honeyful corollas, touching and over-lapping, and rising above one another, glowed in the living light like a sunset sky....

Purple owl clover in a spring meadow, Temblor Range

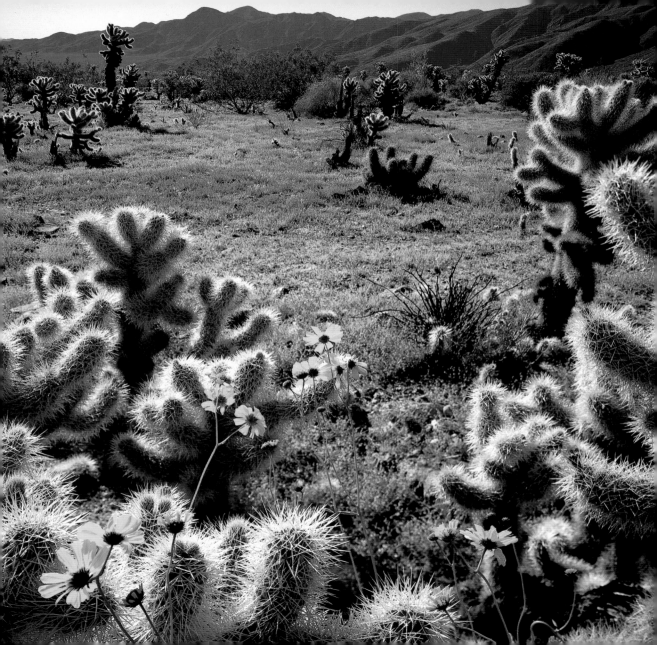

When I first saw this central garden, the most extensive and regular of all the bee-pastures of the State, it seemed all one sheet of plant gold, hazy and vanishing in the distance, distinct as a new map along the foot-hills at my feet.

Descending the eastern slopes of the Coast Range through beds of gilias and lupines, and around many a breezy hillock and bush-crowned headland, I at length waded out into the midst of it. All the ground was covered, not with grass and green leaves, but with radiant corollas, about ankle-deep next the foot-hills, knee-deep or more five or six miles out....

Sauntering in any direction, hundreds of these happy sun-plants brushed against my feet at every step, and closed over them as if I were wading in liquid gold. The air was sweet with fragrance, the larks sang their blessed songs, rising on the wind as I advanced, then sinking out of sight in the polleny sod, while myriads of wild bees stirred the lower air with their monotonous hum — monotonous, yet forever fresh and sweet as everyday sunshine....

The great yellow days circled by uncounted, while I drifted toward the north, observing the countless forms of life thronging about me, lying down almost anywhere on the approach of night. And what glorious botanical beds I had! Often-times on awaking I would find several new species leaning over me and looking me full in the face, so that my studies would begin before rising.

— John Muir
The Mountains of California (1894)

Desert sunflowers amid jumping cholla cactus, Joshua Tree National Park

"A charm that has bound me with the witching power,

For mine is the old belief,

That midst your sweets and midst your bloom,

There's a soul in every leaf!"

— Maturin Murray Ballou, *Flowers*

Douglas' iris, Prairie Creek Redwoods State Park

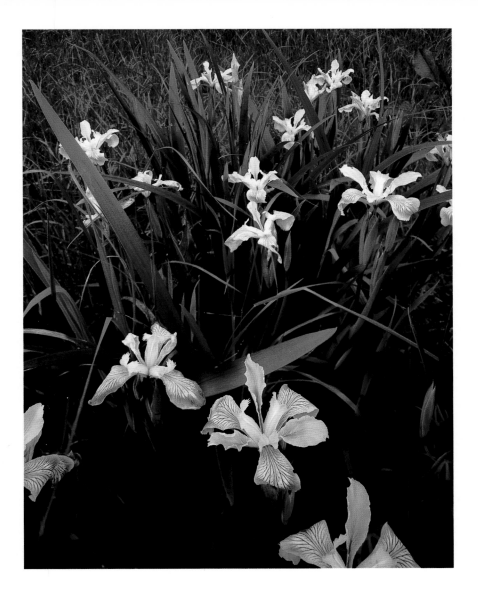

"How does the meadow-flower its bloom unfold?
Because the lovely little flower is free
Down to its root, and, in that freedom bold."

— William Wordsworth,
A Poet! He Hath Put His Heart to School

Field of owl clover, Antelope Valley

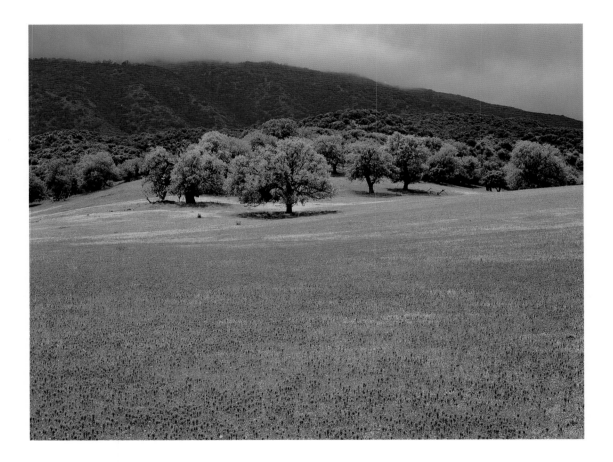

"Nothing is so like a soul as a bee. It goes from
flower to flower as a soul from star to star,
and it gathers honey as a soul gathers light."

— Victor Hugo, *Ninety-Three*

Clover, lupine, and California poppies, Temblor Range

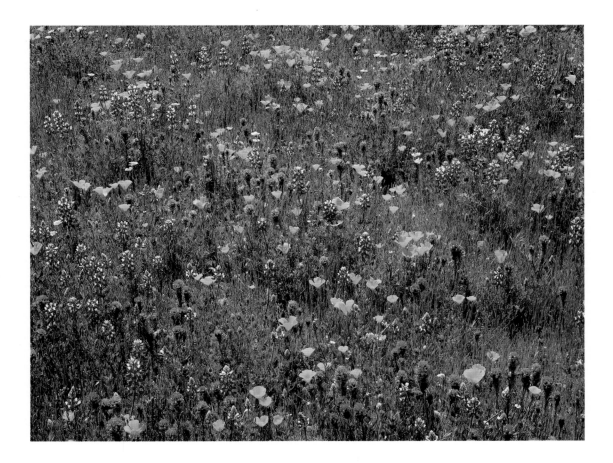

"You must not know too much, or be too precise or
scientific about birds and trees and flowers…
a certain free margin…helps your enjoyment
of these things."

— Walt Whitman, *Specimen Days*

Red Indian paintbrush, Ansel Adams Wilderness

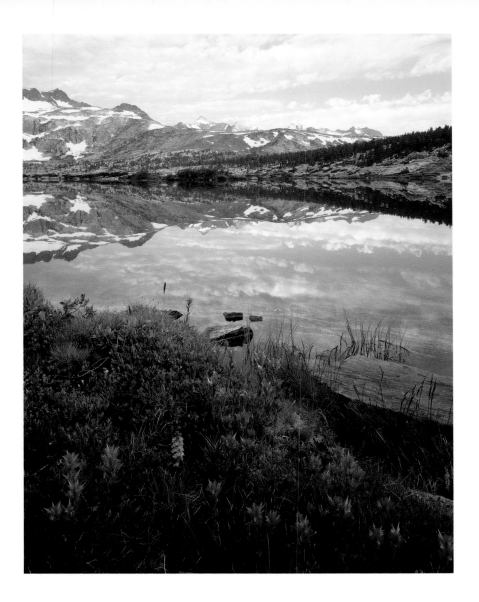

"One of the attractive things about flowers
is their beautiful reserve."

— Henry David Thoreau, *Journal*

Redwood sorrel and salmonberry petal, Redwood National Park

Overleaf: Wild daisies, Plumas County

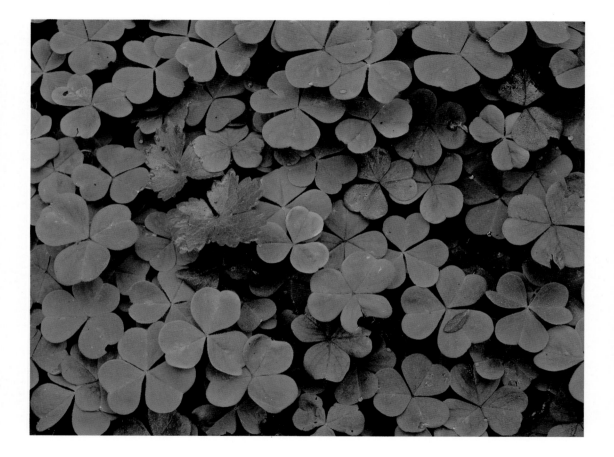

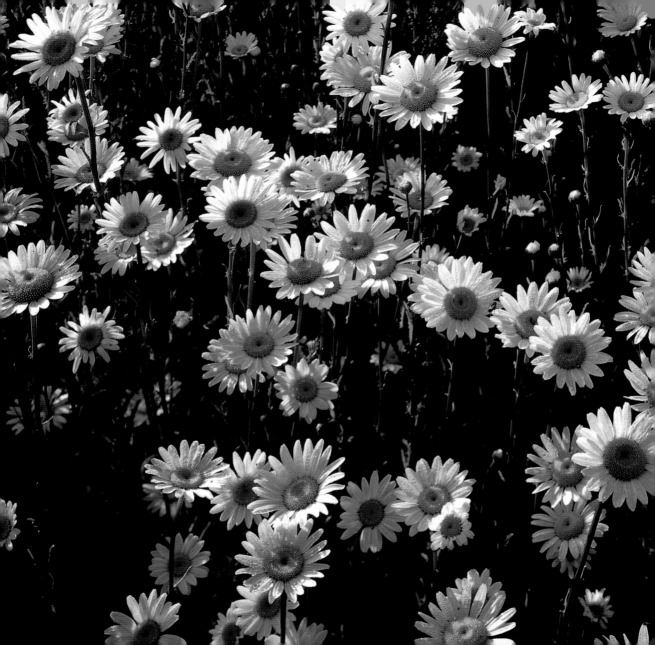

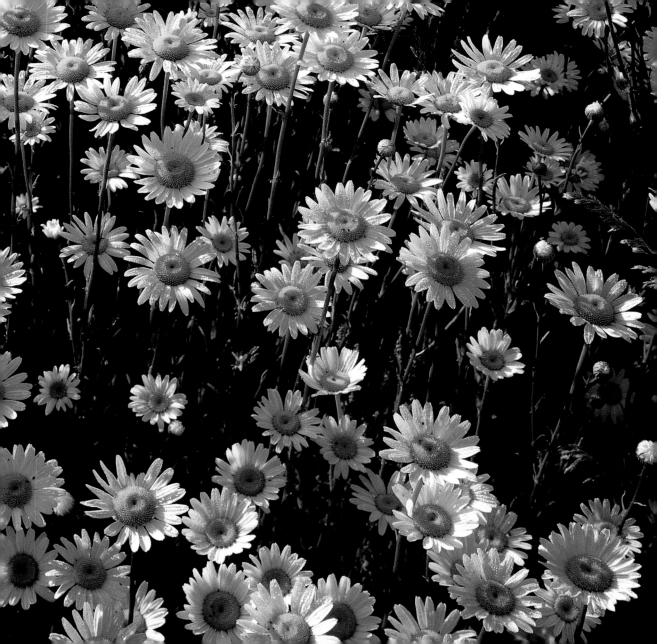

"How cunningly nature hides every wrinkle of her inconceivable antiquity under roses and violets and morning dew!"

— Ralph Waldo Emerson, *The Progress of Culture*

Rose-covered barn, near Fort Bragg

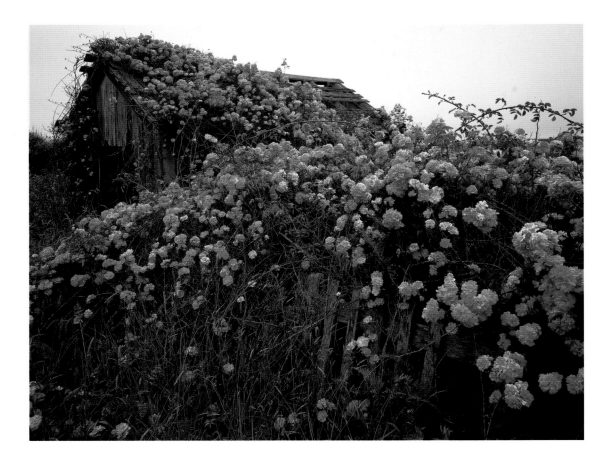

"Nothing in the world is single,

All things by law divine

In one spirit meet and mingle."

— Percy Bysshe Shelley, *Love's Philosophy*

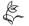

Summer flora, Ansel Adams Wilderness

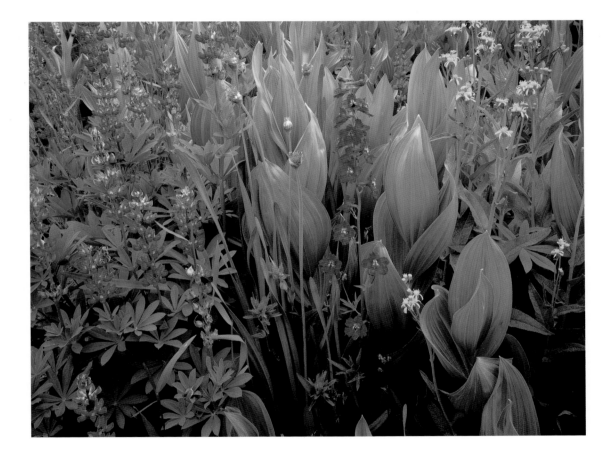

"The loveliest flowers the closest cling to earth…

The happiest of Spring's happy, fragrant birth."

— John Keble, *Spring Showers*

Birdcage evening primrose, Anza-Borrego Desert State Park

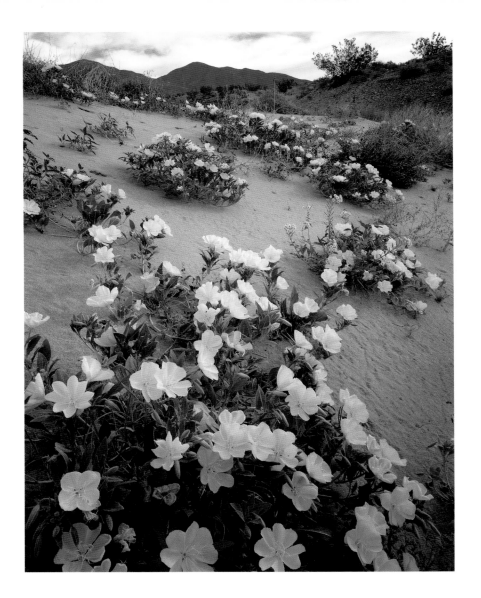

"Beauty is a primeval phenomenon...the reflection of which is visible in a thousand different utterances of the creative mind, and is as various as nature herself."

— Goethe, from Eckermann's *Conversations*

Crimson clover, Klamath Mountains

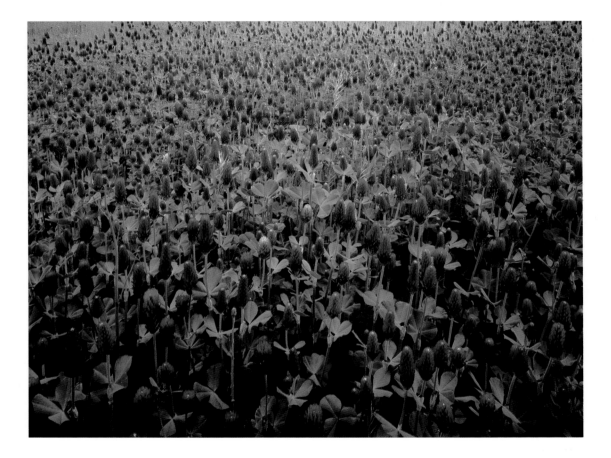

"Flowers have expression of countenance
as much as men or animals. Some seem to smile;
some have a sad expression; some are pensive and diffident;
others again are plain, honest and upright..."

— Henry Ward Beecher, *Star Papers: A Discourse of Flowers*

Desert sunflower, Death Valley National Park

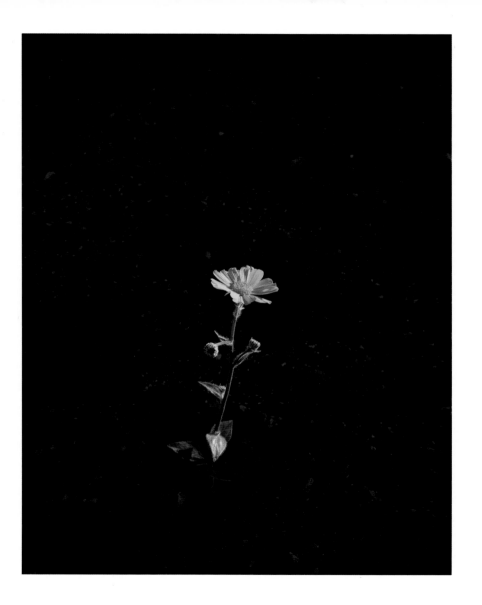

"Throw hither all your quaint enamell'd eyes
That on the green turf suck the honied showers,
And purple all the ground with vernal flowers."

— John Milton, *Lycidas*

Lupine, Carmel Valley

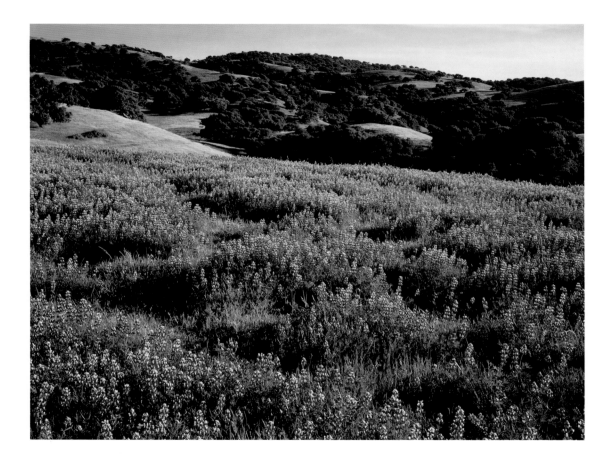

"Flowers are words
Which even a baby may understand."

— Arthur C. Coxe, *The Singing of Birds*

Monkeyflowers, Hoover Wilderness

Overleaf: Summer meadow, Temblor Range

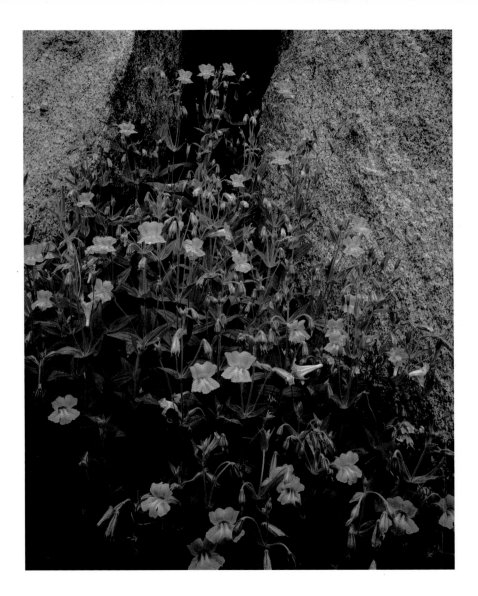

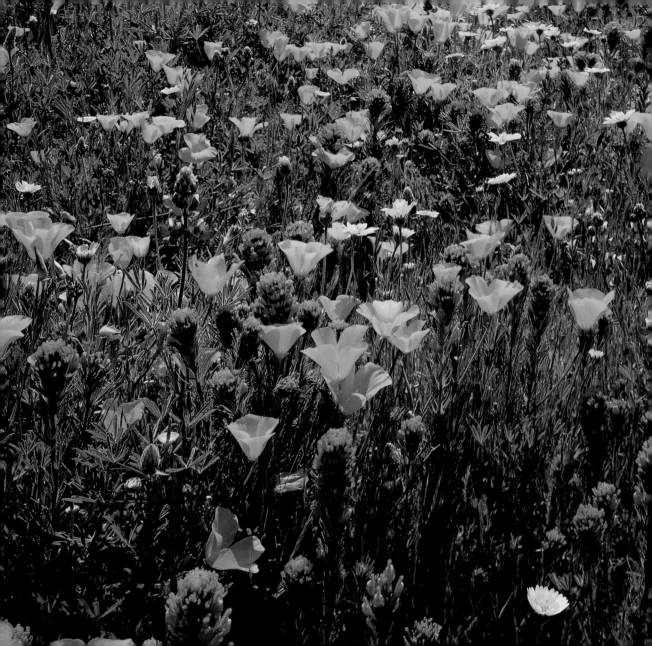

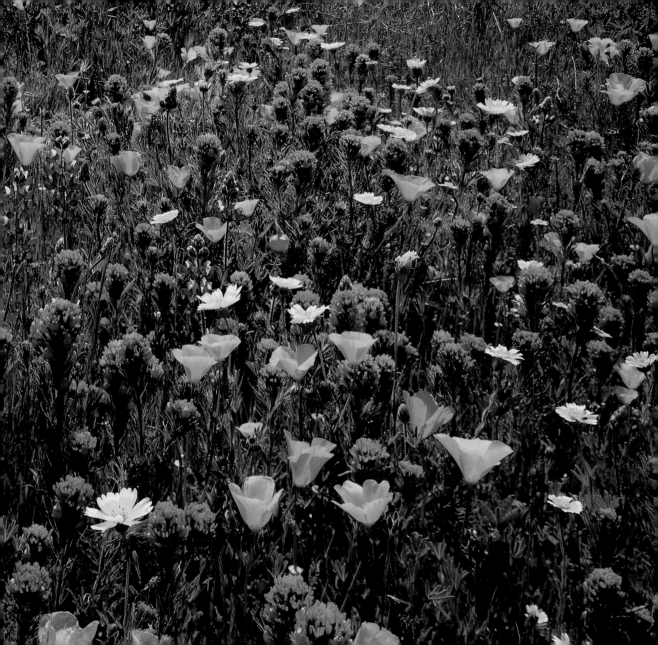

"I should like to enjoy this summer
flower by flower."

— Andre Gide, *Journals*

Poppy-covered hills, Antelope Valley

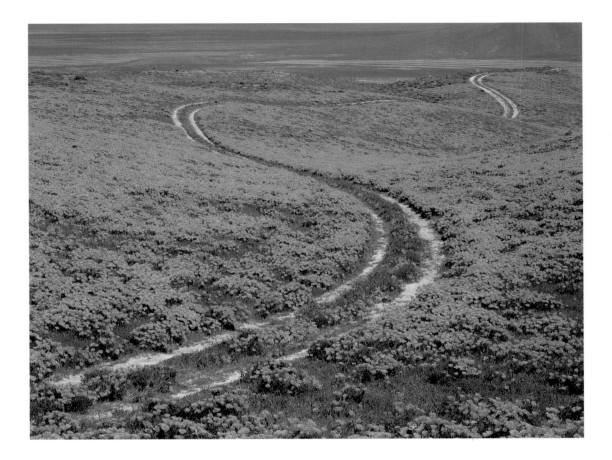

"Beauty is truth, truth beauty—
that is all
Ye know on earth,
and all ye need to know."

— John Keats, *Ode to a Grecian Urn*

Trillium, Humboldt County

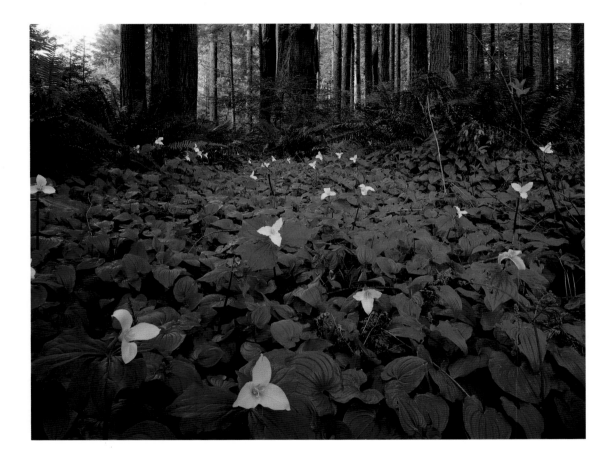

"The earth laughs in flowers."

— Ralph Waldo Emerson, *Hamatreya*

California poppies amid purple owl clover, Antelope Valley

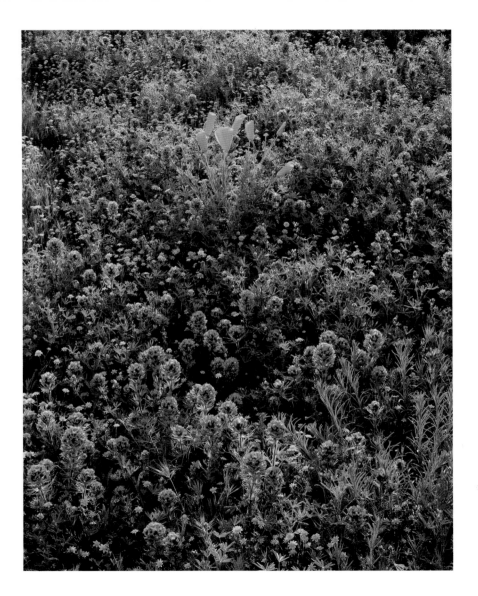

"The flower is the poetry of reproduction. It is an example of the eternal seductiveness of life."

— Jean Giraudoux, *The Enchanted*

Brittlebush and fan palms, Anza-Borrego Desert State Park

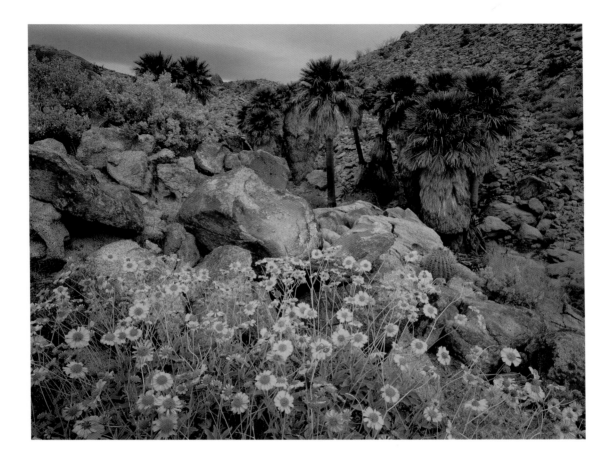

"Spring lightens the green stalk, from thence the leaves
More aerie, last the bright consummate flower."

— John Milton, *Paradise Lost*

Calla lilies, near Big Sur

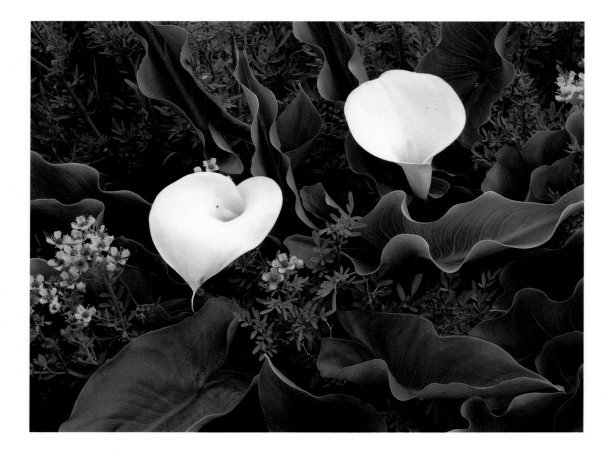

"Beauty is its own excuse for being."

— Ralph Waldo Emerson, *The Rhodora*

Mustard in bloom, Montaña de Oro State Park

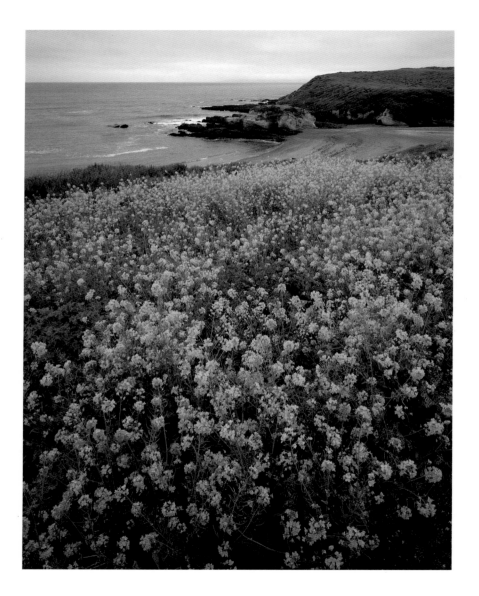

"And 'tis my faith, that every flower

enjoys the air it breathes."

— William Wordsworth, *Lines Written in Early Spring*

Shooting stars, Kings Canyon National Park

Overleaf: Composite flowers, Joshua Tree National Park

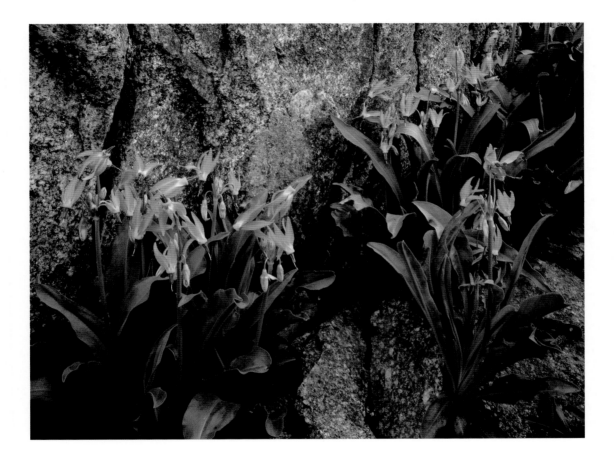

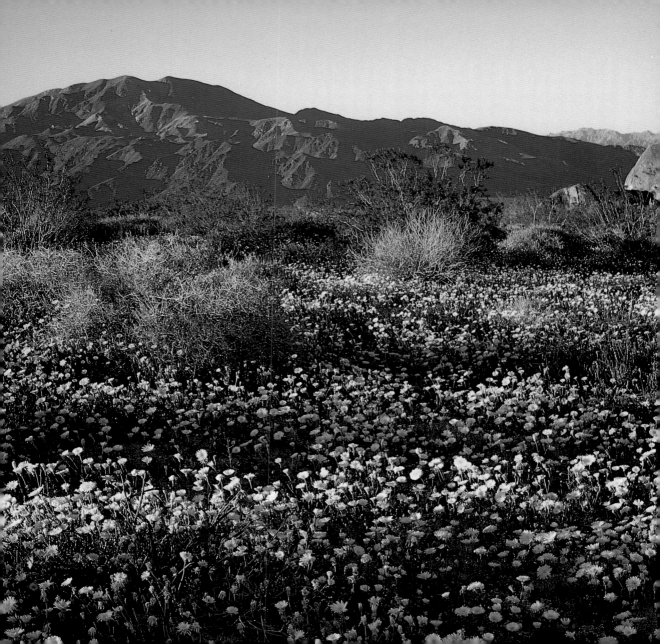

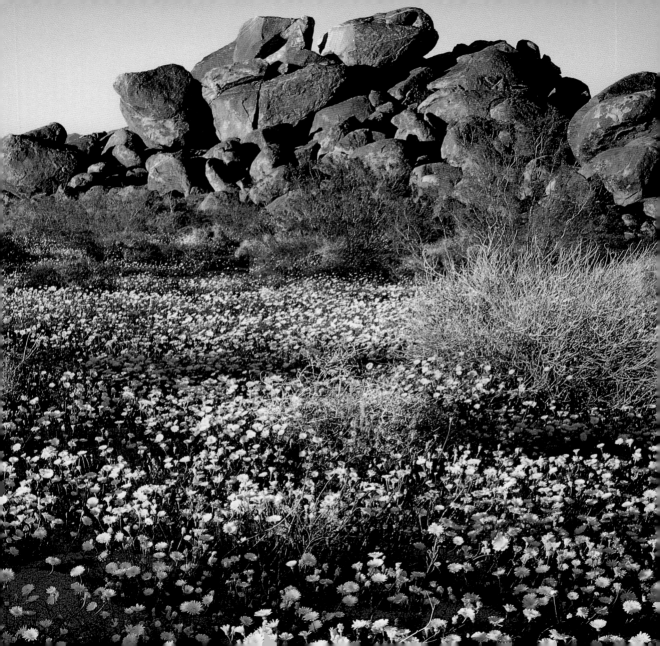

"To create a little flower is the labour of ages."

— William Blake, *Proverbs of Hell*

Moss-covered rhododendron, Redwood National Park

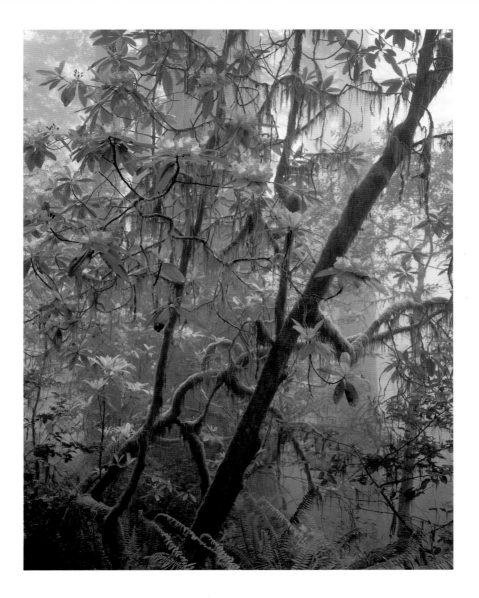

"Flowers…are like lipstick on a woman…it just makes you look better to have a little color."

— Lady Bird Johnson,
Time magazine, September 5, 1989

Indian paintbrush below Banner Peak, Ansel Adams Wilderness

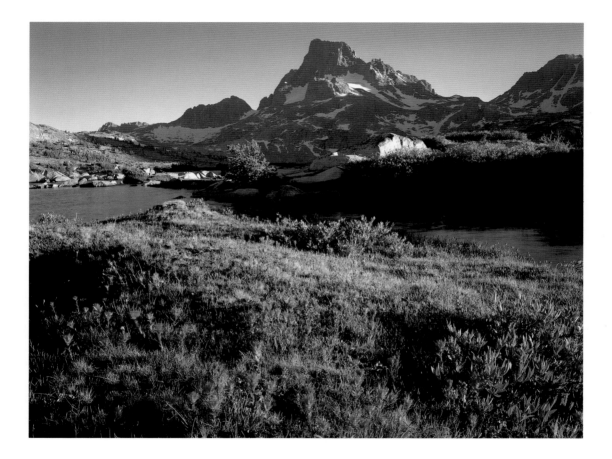

"Work—for some good, be it ever so slowly;

Cherish some flower, be it ever so lowly…"

— Frances Sargent Osgood, *Laborare est Orare*

Flowering hedgehog cactus with wind-blown ocotillo blossoms,
Anza-Borrego Desert State Park

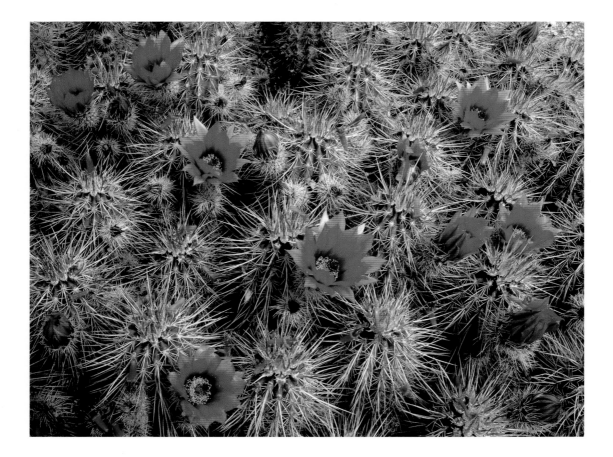

"The Amen! of Nature is always a flower."

— Oliver Wendell Holmes,
The Autocrat of the Breakfast-Table

Lupine, coreopsis, and California poppy, Temblor Range

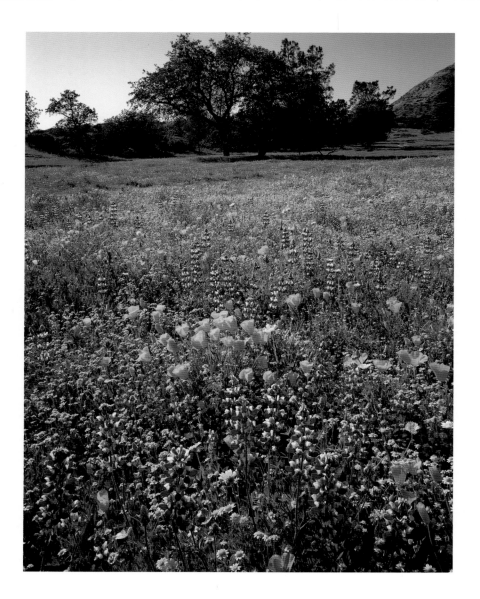

Nature's bouquet, John Muir Wilderness